Education for Socially Engaged Art

Pablo Helguera

Education for Socially Engaged Art

A Materials and Techniques Handbook

Jorge Pinto Books
New York

JORGE
PINTO
BOOKS

Education for Socially Engaged Art

© Pablo Helguera, 2011

Cover image: © Pablo Helguera, *Conferencia Combinatoria,* Museo Universitario de Arte Contemporáneo, Mexico City, 2010

Book typesetting: Charles King: www.ckmm.com

ISBN: 978-1-934978-59-7
1-934978-59-0

Contents

Note

Fragments of this work have appeared in a series of writings I have published on the subject. These include the essays "Open House/Closed House" (published online, 2006) "Alternative Audiences and Instant Spaces" (in *Playing by the Rules: Alternative Thinking/Alternative Spaces*, ed. Steven Rand [New York: Apexart, 2010]), "Notes toward a Transpedagogy" (in *Art, Architecture, Pedagogy: Experiments in Learning*, ed. Ken Ehrlich [Valencia, Calif.: Center for Integrated Media at CalArts, 2009]), and "*Pedagogía y práctica social*" (in *Errata* [Bogotá], education special issue ed. Luis Camnitzer, June 2011).

Introduction

This brief book is meant to serve as an introductory reference tool to art students and others interested in learning about the practice of socially engaged art. I was motivated to write it after being invited by Harrell Fletcher and Jen de los Reyes to teach a course at Portland State University on the subject, which prompted my search for adequate reading materials on the practice.

In the United States, socially engaged art is rooted in the late 1960s, in the seminal influence of Alan Kaprow, the incorporation of feminist education theory in art practice, the exploration of performance and pedagogy by Charles Garoian, and the work of Suzanne Lacy on the West Coast and elsewhere, among many other examples. The practice of socially engaged art today, often referred to as "social practice," has been lately formalized and integrated into art schools, more or less along with academic literature that addresses the phenomenon. Over the last decade, several scholars have started to focus on the subject: Claire Bishop, Tom Finkelpearl, Grant Kester, Miwon Kwon, and Shannon Jackson, among others, have been key in providing interpretations and reflections on how the practice is being shaped, what historical background nourishes it, and the aesthetic issues it raises. The process of theorization of socially engaged art, however, has developed much faster than the more pedestrian discussion of the technical components that constitute it.

Other areas of art-making (painting, printmaking, photography) have nuts-and-bolts technical manuals that guide practitioners in understanding the elements of their practice and achieving the results they want. Those of us working in socially engaged art need our own reference book of "materials and techniques," as it were. I thought it would be useful to make available a brief reference guide that is based on concrete knowledge, experience, and conclusions derived from specific applications of various interactive formats, from discursive and pedagogical methods to real-life situations. The goal of this small book is to serve not as a theoretical text nor a comprehensive set of references, but instead to offer a few examples of how to use art in the social realm, describing the debates around theory as well as some of the more familiar and successful applications of the ideas.

In setting a curriculum for socially engaged art, mere art history and theory won't do: while they are critical to providing a historical and contextual framework of the practice, socially engaged art is a form of performance in the expanded field, and as such it must break away, at least temporarily, from self-referentiality. One is better served by gathering knowledge from a combination of the disciplines—pedagogy, theater, ethnography, anthropology, and communication, among others—from which artists construct their vocabularies in different combinations depending on their interests and needs.

This book presents an introduction to socially engaged art primarily through the tools of education. Partially, this is due to a personal bias: I came to art and education

simultaneously, in 1991, when I first worked in an education department at a museum and initiated my experiments in performance. Gradually I noticed parallels between the processes of art and education. The experience has led me to believe that some of the greater challenges in creating socially engaged artworks can be successfully addressed by relying on the field of education, which historically has navigated similar territories. Today, it is no secret that standard education practices—such as engagement with audiences, inquiry-based methods, collaborative dialogues, and hands-on activities—provide an ideal framework for process-based and collaborative conceptual practices. It is no surprise that artists who work in this area feel at home in the education departments of museums, even if they would also like to be recognized by their curatorial departments.

One example of the usefulness of the tools of education to socially engaged art is the story of Reggio Emilia. Shortly after the end of World War II, in the Northern Italian city of Reggio Emilia, a group of parents led by an educator named Loris Malaguzzi started a school for early childhood education that incorporated the pedagogical thought of John Dewey, Jean Piaget, and others. The goal was to reenvision the child not as an empty container to be filled with facts but as an individual with rights, great potential, and diversity (what Malaguzzi described as "the hundred languages of children").* Based on the curriculum

* See C. Edwards, L. Gandini and G. Form, *The Hundred Languages of Children: The Reggio Emilia Approach Advanced Reflections*, Elsevier Science, Amsterdam: 1998.

they developed, the Reggio Emilia Approach calls for sessions are spontaneous, creative, and collaborative in nature, and children play a critical role in deciding which activities they will focus on any given day. For the Reggio Emilia *pedagogisti*, "to participate is not to create homogeneity; to participate is to generate vitality."* The visual and the performative are central in Reggio Emilia activities. The *atelieristi*, or workshop teachers, play a key role in being attentive to the interests of the group but also in integrating those interests and activities into the curriculum. In this way, the learning experience of every group is different and it functions as a process of co-construction of knowledge. Collaboration with parents and the process of documentation of the child's learning experience are also critical components of the Reggio Emilia Approach.

At first glance, there appears to be no connection between the early childhood pedagogy that emerged in the mid-twentieth century in a small northern Italian town and the kind of socially engaged artwork featured today in *kunsthalles*, biennials, and contemporary art magazines. Yet, in the debate and criticism around such artwork it is necessary to qualify the kind of participation or collaboration that takes place, to describe the experience, the role of the location, the instigator of the action, and the documentation process. All these subjects are carefully considered in the Reggio Emilia Approach, in sophisticated detail and with a nuanced understanding of the individual's cognitive abilities and potential for learning through experience.

* "*Partecipare non é homogenitá; partecipare e vitalitá.*" Elena Giacopini, Reggio Emilia educator, in conversation with the author, June 2011.

Obviously, the work done in Reggio Emilia is not geared to the formation of visual artists, the creation of artworks, nor the insertion of ideas in the art discourse, yet an artist who wants to learn about collaborative dynamics and experimentation as well as the effect that a particular type of documentation may have on the work would be well served by following the roads traversed by these and other educators, roads outlined in this book.

The development of a materials and techniques handbook for socially engaged art might suggest the institution of an academic ideal for the practice that can be measured in scientific ways. In Europe, where art programs in universities are subject to extreme regulation and standardization so that they meet certain educational outcomes, a book like this might be assumed to subject art to cold numbers. Or the existence of a book like this might inspire a more troubling assumption: that a certain set of social-engineering formulas will be recommended, to be deployed to construct a given art experience. I am aware that the subject of influencing a group of people is, in itself, highly controversial, as the implementation of such ideas has created authoritarian cults, repressive regimes, and closed, intolerant societies.

Those who hold such troubling thoughts can rest assured that this book does not turn socially engaged art into a set of academic rules nor push it in the direction of, say, a sort of relational eugenics. Instead, I show that socially engaged art can't be produced inside a knowledge vacuum. Artists who wish to work with communities, for whatever reason, can greatly benefit from the knowledge

accumulated by various disciplines—such as sociology, education, linguistics, and ethnography—to make informed decisions about how to engage and construct meaningful exchanges and experiences. The objective is not to turn us into amateur ethnographers, sociologists, or educators but to understand the complexities of the fields that have come before us, learn some of their tools, and employ them in the fertile territory of art.*

This book, in describing the equivalent of materials and techniques for socially engaged art, may appear to the reader to be a manifesto for best practices. But how can the concept of "best practices" relate to socially engaged art? Is it acceptable to articulate ideal practices, or would that be detrimental to the autonomy of art-making, which needs opacity and ambiguity to exist? While we need critical frameworks—such as those articulated in this book—to make art, they should not be understood as regulatory mandates that would impose moral or ethical demands on art-making. Unethical artistic actions, while crossing the line of acceptability and even legality in some cases, are part of the role that art plays in challenging assumptions in society, and for that reason freedom of expression must always be defended. In any case, to impose a sort of methodology, or "school of thought," onto the practice would only create an interpretation of art-making that the next artist will inevitably challenge, as part of the natural dynamics of art.

* It must be noted that, because both subjective anthropology and performance art developed in the early 1970s, interdisciplinary experimentation and crossover was consciously explored—and exploited, in partnerships—in many notable artworks during that era.

For that reason this book does not assume, nor does it pretend to propose, a system of regulation or schooling of socially engaged art. It doesn't propose, either, a best practices approach for this kind of art. However, socially engaged art-making crosses overtly into other disciplines and tries to influence the public sphere in its language and processes, and it would be absurd to ignore the perfectly useful models that exist in those disciplines. As artists, we may walk blindly into a situation and instigate an action or experience. But unless we don't really care about the outcome, it is important to be aware of why we are acting and to learn how to act in an effective way. Learning how to moderate a conversation, negotiate among interests in a group, or assess the complexities of a given social situation does not curtail artistic liberty; these are skills that can be used to support our activities. Understanding the social processes we are engaging in doesn't oblige us to operate in any particular capacity; it only makes us more aware of the context and thus allows us to better influence and orchestrate desired outcomes.

I have also grappled with another question: Is possible to distinguish and define successful and unsuccessful socially engaged artworks? To argue, for instance, that good socially engaged art creates constructive personal relationships is wrong: an artist's successful project could consist of deliberate miscommunication, in upsetting social relations, or in simply being hostile to the public. This debate belongs to the field of art criticism, addressed by the scholars I have previously mentioned, and it lies outside the scope of this project. Instead, this book is about

understanding and working with audience engagement and response for an artistic purpose. My hope is that an understanding of the nuances of these dynamics will be useful for artists but also for those who are interested in understanding and commenting in a thoughtful and critical way on the projects that emerge in this field.

Porto Alegre/Bologna/Brooklyn,
June 2011

Definitions

What do we mean when we say "socially engaged art"? As the terminology around this practice is particularly porous, it is necessary to create a provisional definition of the kind of work that will be discussed here. All art, inasmuch as it is created to be communicated to or experienced by others, is social. Yet to claim that all art is social does not take us very far in understanding the difference between a static work such as a painting and a social interaction that proclaims itself as art—that is, socially engaged art.

We can distinguish a subset of artworks that feature the experience of their own creation as a central element. An action painting is a record of the gestural brushtrokes that produced it, but the act of executing those brushstrokes is not the primary objective of its making (otherwise the painting would not be preserved). A Chinese water painting or a mandala, by contrast, is essentially *about*

the process of its making, and its eventual disappearance is consistent with its ephemeral identity. Conceptualism introduced the thought process as artwork; the materiality of the artwork is optional.

Socially engaged art falls within the tradition of conceptual process art. But it does not follow that all process-based art is also socially engaged: if this were so, a sculpture by Donald Judd would fall in the same category as, say, a performance by Thomas Hirshhorn. Minimalism, for instance, though conceptual and process based, depends on processes that ensure the removal of the artist from the production—eliminating the "engagement" that is a definitive element of socially engaged art.

While there is no complete agreement as to what constitutes a meaningful interaction or social engagement, what characterizes socially engaged art is its dependence on social intercourse as a factor of its existence.

Socially engaged art, as a category of practice, is still a working construct. In many descriptions, however, it encompasses a genealogy that goes back to the avant-garde and expands significantly during the emergence of Post-Minimalism.* The social movements of the 1960s led to greater social engagement in art and the emergence of performance art and installation art, centering on process and site-specificity, which all influence socially engaged art practice today. In previous decades, art based on social interaction has been identified as "relational aesthetics" and

* In this book it is not possible (nor is it the goal) to trace a history of socially engaged art; instead I focus mainly on the practice as it exists today, with reference to specific artists, movements, and events that have significantly informed it.

"community," "collaborative," "participatory," "dialogic," and "public" art, among many other titles. (Its redefinitions, like that of other kinds of art, have stemmed from the urge to draw lines between generations and unload historical baggage.) "Social practice" has emerged most prominently in recent publications, symposia, and exhibitions and is the most generally favored term for socially engaged art. The new term excludes, for the first time, an explicit reference to art-making. Its immediate predecessor, "relational aesthetics," preserves the term in its parent principle, aesthetics (which, ironically, refers more to traditional values—i.e., beauty—than does "art"). The exclusion of "art" coincides with a growing general discomfort with the connotations of the term. "Social practice" avoids evocations of both the modern role of the artist (as an illuminated visionary) and the postmodern version of the artist (as a self-conscious critical being). Instead the term democratizes the construct, making the artist into an individual whose specialty includes working with society in a professional capacity.

Between Disciplines

The term "social practice" obscures the discipline from which socially engaged art has emerged (i.e., art). In this way it denotes the critical detachment from other forms of art-making (primarily centered and built on the personality of the artist) that is inherent to socially engaged art, which, almost by definition, is dependent on the involvement of others besides the instigator of the artwork. It also thus

raises the question of whether such activity belongs to the field of art at all. This is an important query; art students attracted to this form of art-making often find themselves wondering whether it would be more useful to abandon art altogether and instead become professional community organizers, activists, politicians, ethnographers, or sociologists. Indeed, in addition to sitting uncomfortably between and across these disciplines and downplaying the role of the individual artist, socially engaged art is specifically at odds with the capitalist market infrastructure of the art world: it does not fit well in the traditional collecting practices of contemporary art, and the prevailing cult of the individual artist is problematic for those whose goal is to work with others, generally in collaborative projects with democratic ideals. Many artists look for ways to renounce not only object-making but authorship altogether, in the kind of "stealth" art practice that philosopher Stephen Wright argues for, in which the artist is a secret agent in the real world, with an artistic agenda.*

Yet the uncomfortable position of socially engaged art, identified as art yet located between more conventional art forms and the related disciplines of sociology, politics, and the like, is exactly the position it should inhabit. The practice's direct links to and conflicts with both art and sociology must be overtly declared and the tension addressed, but not resolved. Socially engaged artists can and should challenge the art market in attempts to redefine the

* See "*Por un arte clandestino*," the author's conversation with Stephen Wright in 2006, http://pablohelguera.net/2006/04/por-un-arte-clandestino-conversacion-con-stephen-wright-2006/. Wright later wrote a text based on this exchange, http://www.entrepreneur.com/tradejournals/article/153624936_2.html.

notion of authorship, but to do so they must accept and affirm their existence in the realm of art, as artists. And the artist as social practitioner must also make peace with the common accusation that he or she is not an artist but an "amateur" anthropologist, sociologist, etc. Socially engaged art functions by attaching itself to subjects and problems that normally belong to other disciplines, moving them temporarily into a space of ambiguity. It is this temporary snatching away of subjects into the realm of art-making that brings new insights to a particular problem or condition and in turn makes it visible to other disciplines. For this reason, I believe that the best term for this kind of practice is what I have thus far been using as a generic descriptor—that is, "socially engaged art" (or SEA), a term that emerged in the mid-1970s, as it unambiguously acknowledges a connection to the practice of art.*

Symbolic and Actual Practice

To understand SEA, an important distinction must be made between two types of art practice: symbolic and actual. As I will show, SEA is an actual, not symbolic, practice.

A few examples:

- Let's say an artist or group of artists creates an "artist-run school," proposing a radical new approach to teaching. The project is presented as an art project but also as a functioning school (a relevant example,

* From this point forward I will use this term to refer to the type of artwork that is the subject of this book.

given the recent emergence of similar projects). The "school," however, in its course offerings, resembles a regular, if slightly unorthodox, city college. In content and format, the courses are not different in structure from most continuing education courses. Furthermore, the readings and course load encourage self-selectivity by virtue of the avenues through which it is promoted and by offering a sampling that is typical of a specific art world readership, to the point that the students taking the courses are not average adults but rather art students or art-world insiders. It is arguable, therefore, whether the project constitutes a radical approach to education; nor does it risk opening itself up to a public beyond the small sphere of the converted.

• An artist organizes a political rally about a local issue. The project, which is supported by a local arts center in a medium-size city, fails to attract many local residents; only a couple dozen people show up, most of whom work at the arts center. The event is documented on video and presented as part of an exhibition. In truth, can the artist claim to have organized a rally?

These are two examples of works that are politically or socially motivated but act through the *representation* of ideas or issues. These are works that are designed to address social or political issues only in an allegorical, metaphorical, or symbolic level (for example, a painting about social issues is not very different from a public art

project that claims to offer a social experience but only does so in a symbolic way such as the ones just described above). The work does not control a social situation in an instrumental and strategic way in order to achieve a specific end.

This distinction is partially based on Jürgen Habermas's work *The Theory of Communicative Action* (1981). In it Habermas argues that social action (an act constructed by the relations between individuals) is more than a mere manipulation of circumstances by an individual to obtain a desired goal (that is, more than just the use of strategic and instrumental reason). He instead favors what he describes as communicative action, a type of social action geared to communication and understanding between individuals that can have a lasting effect on the spheres of politics and culture as a true emancipatory force.

Most artists who produce socially engaged works are interested in creating a kind of collective art that affects the public sphere in a deep and meaningful way, not in creating a representation—like a theatrical play—of a social issue. Certainly many SEA projects are in tune with the goals of deliberative democracy and discourse ethics, and most believe that art of any kind can't avoid taking a position in current political and social affairs. (The counter-argument is that art is largely a symbolic practice, and as such the impact it has on a society can't be measured directly; but then again, such hypothetical art, as symbolic, would not be considered socially engaged but rather would fall into the other familiar categories, such as installation, video, etc.) It is true that much SEA

is composed of simple gestures and actions that may be perceived as symbolic. For example, Paul Ramirez-Jonas's work *Key to the City* (2010) revolved around a symbolic act—giving a person a key as a symbol of the city. Yet although Ramirez-Jonas's contains a symbolic act, it is not symbolic practice but rather communicative action (or "actual" practice)—that is, the symbolic act is part of a meaningful conceptual gesture.*

The difference between symbolic and actual practice is not hierarchical; rather, its importance lies in allowing a certain distinction to be made: it would be important, for example, to understand and identify the difference between a project in which I establish a health campaign for children in a war-torn country and a project in which I imagine a health campaign and fabricate documentation of it in Photoshop. Such a fabrication might result in a fascinating work, but it would be a symbolic action, relying on literary and public relations mechanisms to attain verisimilitude and credibility.

To summarize: social interaction occupies a central and inextricable part of any socially engaged artwork. SEA is a hybrid, multi-disciplinary activity that exists somewhere between art and non-art, and its state may be permanently unresolved. SEA depends on actual—not imagined or hypothetical—social action.

What will concern us next is how SEA can bring together, engage, and even critique a particular group of people.

* Paul Ramirez Jonas's project, produced by Creative Time, took place in New York City in the Summer of 2010.

II

Community

In this section I will consider some of the defining elements around group relationships created through SEA. They include, A: The construction of a community or temporary social group through a collective experience; B: The construction of multi-layered participatory structures; C: The role of social media in the construction of community; D: The role of time; E: Assumptions about audience.

A. The Construction of a Community

"Community" is a word commonly associated with SEA. Not only does each SEA project depend on a community for its existence, but such projects are, most people agree, community-building mechanisms. But what kind of community does SEA aspire to create? The relationships that artists establish with the communities they work with

can vary widely; SEA projects may have nearly nothing in common.

Shannon Jackson compares and contrasts SEA projects in her study *Social Works: Performing Art, Supporting Publics*, juxtaposing the community art project Touchable Stories (begun 1996), by Shannon Flattery, which seeks to help "individual communities define their own voice," the artist says, and the work of Santiago Sierra, who pays workers from disadvantaged and marginalized groups to do demeaning tasks.* These projects are both accepted as SEA, yet they could not be more different.

The typical community art project (for instance, a children's mural project) is able to fulfill its purpose of strengthening a community's sense of self by lessening or suspending criticality regarding the form and content of the product and, often, promoting "feel-good" positive social values.† Sierra's work, at the opposite end of the spectrum, exploits individuals with the goal of denouncing exploitation—a powerful conceptual gesture that openly embraces the ethical contradiction of denouncing that which one perpetrates. Sierra's community of participants is financially contracted; they participate in order to get paid, not out of interest or for their love for art.

* Shannon Jackson, *Social Works: Performing Art, Supporting Publics* (London: Routledge, 2011), p. 43.

† This is not meant to be a critique of community art, which, like all forms of art, exists in more and less successful iterations. Nor is it a critique of Sierra's practice. The examples are presented merely to illustrate the spectrum along which collaboration and confrontation operate.

To further complicate matters, let's say that SEA is successful inasmuch as it builds community bonds. By this logic, Sierra's work would not be a successful one but the children's mural project would hold together, as it helps build community. This thinking would not hold true to art world standards, which consider Sierra's conceptual gestures—if objectionable—as more sophisticated and relevant to the debates around performance and art than the average community mural. Furthermore, is it still successful SEA if the community fostered by an art work is a racist hate group? This points to a larger, unresolved issue: Does SEA, by definition, have particular goals when it comes to engaging a community?

All art invites social interaction; yet in the case of SEA it is the process itself—the fabrication of the work—that is social. Furthermore, SEA is often characterized by the activation of members of the public in roles beyond that of passive receptor. While many artworks made over the last four decades have encouraged the participation of the viewer (Fluxus scores and instructions, installations by Felix Gonzalez-Torres, and most works associated with relational aesthetics, such as Rirkrit Tiravanija's shared meals), this participation mostly involves the execution of an idea (following a Fluxus instruction, for example) or the free partaking of the work in a open-ended social environment (such as sharing a meal).

SEA, as it is manifested today, continues in the spirit of these practices but often expands the depth of the social relationship, at times promoting ideas such as

empowerment, criticality, and sustainability among the participants. Like the political and activist art inspired by 1970s feminism and identity politics, SEA usually has an overt agenda, but its emphasis is less on the act of protest than on becoming a platform or a network for the participation of others, so that the effects of the project may outlast its ephemeral presentation.

Sierra's performance and the children's mural project exemplify the extremes of SEA because they adopt social interaction strategies of total confrontation and total harmony, respectively. Neither of these extremes leads easily to, or is the result of, a critically self-reflexive dialogue with an engaged community, which is, as I will try to argue, a key pursuit for the majority of works within this practice.

One factor of SEA that must be considered is its expansion to include participants from outside the regular circles of art and the art world. Most historical participatory art (thinking from the avant-gardes to the present) has been staged within the confines of an art environment, be it a gallery, museum, or event to which visitors arrive predisposed to have an art experience or already belonging to a set of values and interests that connect them to art. While many SEA projects still follow this more conservative or traditional approach, the more ambitious and risk-taking projects directly engage with the public realm—with the street, the open social space, the non-art community—a task that presents so many variables that only few artists can undertake it successfully.

Currently, perhaps the most accepted description of the community SEA creates is "emancipated"; that is, to use Jacques Rancière's oft-quoted words, "a community of narrators and translators."* This means that its participants willingly engage in a dialogue from which they extract enough critical and experiential wealth to walk away feeling enriched, perhaps even claiming some ownership of the experience or ability to reproduce it with others. To understand what this dialogue may consist of, it is important to understand what we mean by interaction. Like the division between insider and outsider art and the definition of community, there is no general, agreed-upon understanding of participation, engagement, or collaboration. As mentioned above, in some conceptual art, the role of the participant is nominal; he or she may be an instrument for the completion of the work (for Marcel Duchamp, for example) or a directed performer (in a Fluxus piece). There are as many kinds of participation as there are participatory projects, but nominal or symbolic interaction cannot be equated with an in-depth, long-term exchange of ideas, experiences, and collaborations, as their goals are different. To understand these different approaches allows for a sense of what each can accomplish.

* Jacques Rancière, *The Emancipated Spectator* (London: Verso, 2009), p. 22.

B. Multi-Layered Participatory Structures

Participation, as a blanket term, can quickly lose its meaning around art. Do I participate by simply entering an exhibition gallery? Or am I only a participant when I am actively involved in the making of a work? If I find myself in the middle of the creation of an artwork but I decline to get involved, have I participated or not? Participation shares the same problem as SEA, as previously discussed. Arguably, all art is participatory because it requires the presence of a spectator; the basic act of being there in front of an artwork is a form of participation. The conditions of participation for SEA are often more specific, and it is important to understand it in the time frame during which it happens.

Some of the most sophisticated SEA offers rich layers of participation, manifested in accordance with the level of engagement a viewer displays. We can establish a very tentative taxonomy:*

1. **Nominal participation.** The visitor or viewer contemplates the work in a reflective manner, in passive detachment that is nonetheless a form of participation. The artist Muntadas posted this warning for one of his exhibitions: "Attention: Perception Requires Participation."

* Suzanne Lacy sketches out participatory structures in another form in her book *Mapping the Terrain: New Genre Public Art* (Seattle: Bay Press, 1995), p. 178.

2. Directed participation. The visitor completes a simple task to contribute to the creation of the work (for example, Yoko Ono's *Wish Tree* [1996] in which visitors are encouraged to write a wish on a piece of paper and hang it on a tree).

3. Creative participation. The visitor provides content for a component of the work within a structure established by the artist (for example, Allison Smith's work *The Muster* [2005], in which fifty volunteers in Civil War uniforms engaged in a reenactment, declaring the causes for which they, personally, were fighting).

4. Collaborative participation. The visitor shares responsibility for developing the structure and content of the work in collaboration and direct dialogue with the artist (Caroline Woolard's ongoing project "Our Goods", where participants offer goods or services on the basis of interest and need, is an example of this way of working).

Usually, nominal and directed participation take place in a single encounter, while creative and collaborative participation tend to develop over longer periods of time (from a single day to months or years).

A work incorporating participation at a nominal or directed level is not necessarily more or less successful or desirable than one featuring creative or collaborative

participation. However, it is important to keep the distinctions in mind, for at least three reasons: first, they help us in outlining the range of possible goals for a participatory framework; second, as I will show later, they can create a useful frame of reference in evaluating a work's intention in relation to its actualization; third, a consideration of the degree of participation a work entails is intimately related to any evaluation of the way in which it constructs a community experience.

In addition to their degree of participation, it is equally important to recognize the predisposition toward participation that individuals may have in a particular project. In social work, individuals or communities (often referred to as "clients") with whom the social worker interacts are divided into three groups: those who actively and willingly engage in an activity, or *voluntary* (such as "Flash mob" type of action, which will be discussed further); those who are coerced or mandated to engage, or *nonvoluntary* (for example, a high school class collaborating in the activist project) and those who encounter a project in a public space or engage in a situation without having full knowledge that it is an art project, or *involuntary*.* An awareness of the voluntary, nonvoluntary, or involuntary predisposition of participants in a given project allows for the formulation of a successful approach to an individual or community, as approaches for participants with different predispositions vary widely. For example, if a participant is willingly and actively engaged as a volunteer, it may be

* See John Pulin and contributors, *Strengths-Based Generalist Practice: A Collaborative Approach* (Belmont:Thomson Brooks/Cole, 2000), p. 15.

in the interest of the artist to make gestures to encourage that involvement. If a participant has been forced to be part of the project for external reasons, it may be beneficial for the artist to acknowledge that fact and, if the objective is engagement, take measures to create a greater sense of ownership for that person. In the case of involuntary participants, the artist may decide to hide the action from them or to make them aware at a certain point of their participation in the art project.

Institutions such as Machine Project in Los Angeles, Morgan J. Puett's and Mark Dion's Mildred's Lane in Pennsylvania, or Caroline Woolard's Trade School in New York offer environments in which visitors gradually develop sets of relationships that allow them to contribute meaningfully in the construction of new situations, effectively becoming not only interlocutors but collaborators in a joint enterprise.

C. Virtual Participation: Social Media

This book does not aim to encompass the online world, but a word should be said about the relationship between face-to-face and virtual sociality. It is relevant that the use of "social practice" as a term rose almost in perfect synch with new, online social media. This parallelism can be interpreted in many ways: perhaps the new iteration of SEA was inspired by the new fluidity of communication, or, alternatively, perhaps it was a reaction against the ethereal nature of virtual encounters, an affirmation of the personal and the local. The likelihood is that recent

forms of SEA are both a response to the interconnectivity of today's world and the result of a desire to make those connections more direct and less dependent on a virtual interface. In any case, social networks have proven to be very effective forms for instigating social action. In a flash mob, a group of people, usually of strangers, suddenly congregates, directed to the same spot via communication from a leader over an online social network. While flash mobs usually don't proclaim themselves as artworks, they do fall neatly into the category of directed participation outlined above. In addition, online social networks have proven to be useful platforms for the organization of carefully planned political actions. Much has been made recently of the ways in which Twitter and Facebook helped bring large groups of people together in events connected with the so-called Arab Spring of 2011, and the social significance of these gatherings can't be considered merely symbolic. Art projects that, in a much more humble way, offer a time and space for congregation and developing relationships also can serve an important role in helping diverse groups of people—neighbors, students, a group of artists—find commonalities through activities.

Social networks and other online platforms can be very beneficial vehicles for continuing work that has been started in person. Online learning platforms like Blackboard and Haiku provide spaces in which community members can interact, commenting and exchanging information on the production of a project. These platforms have their own idiosyncrasies and etiquette, but for the most part the general rules of social interaction apply.

D. Time and Effort

If there is something common to every pedagogical approach, it is an emphasis on the necessity of investing time to achieve a goal. Some educational goals simply can't be achieved if one is not willing to invest time: you can't learn a language in a day; you can't become an expert in martial arts at a weekend workshop. According to Malcolm Gladwell, it takes about ten thousand hours of practice to become expert at anything.* A museum can hold an art workshop for a school, but the school must commit to a time frame of, say, at least three hours if the experience is to be successful. Even very limited time periods of engagement can be productive when goals are clearly set: a one-hour gallery conversation at a museum for a non-specialized audience can't turn visitors into art specialists, but it can be effective in inspiring interest in a subject and making a focused point about a particular kind of art or artist.

Many problems in community projects are due to unrealistic goals in relation to the expected time investment. An SEA project can make particularly great demands of time and effort on an artist—demands that are usually at odds with the time constraints posed by biennials and other international art events, let alone the pressure for product and near-immediate gratification from the art market. This may be the single biggest reason why SEA projects

* See chapter two of Malcolm Gladwell, *Outliers* (New York: Little Brown & Co., 2008).

fail to succeed. An artist may be invited by a biennial a few months in advance of the event to do a site-specific community collaboration. By the time the artist has found a group of people to work with (which is not always easy or even possible), it is likely that the time for developing the project is limited, and the end result may be rushed. Most successful SEA projects are developed by artists who have worked in a particular community for a long time and have an in-depth understanding of those participants. This is also why SEA projects, like exotic fruit, usually travel poorly when "exported" to other locations to be replicated.

In rare instances, artists or curators have the luxury of spending a long time in a particular location, with very rich results. A prime example is France Morin's ongoing project *The Quiet in the Land*, a series of SEA projects that have each taken several years to accomplish. Morin's remarkable determination has allowed her (and teams of artists) to successfully engage with communities as disparate as the Shakers of Sabbathday Lake, Maine, and the monks and novices, artisans, and students of Luang Prabang, Laos. Morin acts as catalyst for the development of artists' projects, moving into the regions where she is interested in working several years in advance of the work period to gain the trust of the community. Her interest lies in creating projects that "strive to activate the 'space between' groups and individuals as a zone of potentiality, in which the relationship between contemporary art and life may be renegotiated."* Morin's projects are key references

* Quote from *The Quiet in the Land's* website:
http://www.thequietintheland.org/description.php.

for understanding the great demands—and great potential—of artists deeply engaging in a social environment.

E. Audience Questions

"Who is your audience?" This is commonly the first question educators ask about any pedagogical activity in the planning. In art, by contrast, to preestablish an audience is seen by some to restrict a work's possible impact, which is why many artists are usually reluctant to answer that question about their work. Common responses are, "I don't have any audience in mind" and "My audience is whoever is interested."

To some, the idea of an audience for an artwork-in-progress is a contradiction: If the artwork is new, how can an audience for it already exist? By this logic, new ideas—and new types of art—create their own audiences after they are made. I would argue, however, that ideas and artworks have implicit audiences, and this is especially true in the case of SEA, where the audience is often inextricable from the work.

In the movie *Field of Dreams* (1989), an Iowa farmer (played by Kevin Costner) walking through a cornfield suddenly hears a voice saying, "If you build it, he will come." He envisions a baseball field and is strongly compelled to build it. The phrase has entered the English language in the variation of "build it and they will come" as if it is an adage of ancient wisdom and not from the pen of a Hollywood screenwriter. The implied message is that building comes first, audiences second. Yet the

opposite is true. We build *because* audiences exist. We build because we seek to reach out to others, and they will come initially because they recognize themselves in what we have built. After that initial interaction, spaces enter a process of self-identification, ownership, and evolution based on group interests and ideas. They are not static spaces for static viewers but ever-evolving, growing, or decaying communities that build themselves, develop, and eventually dismantle.

Various sociologists have argued—David Berreby most notably—that as humans we are predisposed express a tribal mindset of "us" versus "them," and each statement we make is oriented in relation to a set of preexisting social codes that include or exclude sectors of people.* The contemporary art milieu is most distinctively about exclusion, not inclusion, because the structure of social interactions within its confines are based on a repertory of cultural codes, or passwords, that provide status and a role within a given conversation. Radical, countercultural, or alternative practices employ those exclusionary passwords as well, to maintain a distance from the mainstream.

Many participatory projects that are open, in theory, to the broad public, in fact serve very specific audiences. It could be said that a SEA project operates within three registers: one is its immediate circle of participants and supporters; the second is the critical art world, toward which it usually looks for validation; and the third is

* David Berreby, *Us and Them: The Science of Identity*. Chicago: University of Chicago Press, 2008.

society at large, through governmental structures, the media, and other organizations or systems that may absorb and assimilate the ideas or other aspects of the project. In some cases—in residency programs, for example—visual artists are commissioned to work with a predetermined audience. While these initiatives often result in interesting and successful art projects, they run the risk of limiting the support they can provide to the artist by prescribing set parameters for audiences and spaces, possibly trying to fulfill quotas set by grant makers. Spaces and institutions in this situation often find themselves between a rock and a hard place, trying to sell a very hermetic product—very self-referential, cutting-edge art—to (often non-art) communities with very different interests and concerns.

Audiences are never "others"—they are always very concrete selves. In other words, it is impossible to plan a participatory experience and take steps to make it public without also making some assumption about those who will eventually partake in it. Do they read *Artforum*? Do they watch CNN? Do they speak English? Do they live in Idaho? Do they vote Democrat? When we organize and promote an exhibition or create a public program, we make decisions regarding its hypothetical audience or audiences, even if intuitively. Sociolinguist Allan Bell coined the term "audience design" in 1984, referring to the ways in which the media addresses different types of audiences through "style shifts" in speech.* Since that time,

* Allan Bell, (1984) *Language Style as Audience Design.* In Coupland, N. and A. Jaworski (1997, eds.) *Sociolinguistics: a Reader and Coursebook,* pp. 240–50. New York: St Mattin's Press Inc.

the discipline of sociolinguistics has defined structures by which we can recognize the patterns speakers use to engage with audiences in multiple social and linguistic environments through register and social dialect variations. So if an arts organization is to be thought of as a "speaker," it is possible to conceive of it as operating—through its programs and activities—in multiple social registers that may or may not include an art "intelligentsia," a more immediate contemporary-art audience with its inner codes and references, and the larger public.

Most curators and artists, when I have articulated this view to them, have expressed wariness about the notion of a preconceived audience. To them, it sounds reductive and prone to mistakes. They feel that to identify a certain demographic or social group as the audience for a work may be to oversimplify their individuality and idiosyncrasies—an attitude that may perhaps have grown from critiques of "essentialism" in the early 1980s. I usually turn the question the other way around: Is it possible to *not* conceive of an audience for your work, to create an experience that is intended to be public without the slightest bias toward a particular kind of interlocutor, be it a rice farmer in Laos or a professor of philosophy at Columbia University? The debate may boil down to art practice itself and to the common statement by artists that they don't have a viewer in mind while making their work—in other words, that they only produce for themselves. What is usually not questioned, however, is how one's notion of one's self is created. It is the construct of a vast collectivity of people who have influenced one's thoughts and one's

values, and to speak to one's self is more than a solipsistic exercise—it is, rather, a silent way of speaking to the portion of civilization that is summarized in our minds. It is true that no audience construct is absolute—they all are, in fact, fictional groupings that we make based on biased assumptions. Nonetheless, they are what we have to go by, and experience in a variety of fields has proven that, as inexact as audience constructs may be, it is more productive to work with one than by no presuppositions whatsoever.

The problem doesn't lie in the decision whether or not to reach for large or selective audiences but rather in understanding and defining which groups we wish to speak to and in making conscious steps to reach out to them in a constructive, methodical way: for example, an artist attempting to find an audience may not benefit by trying experimental methods—he or she could be better served by traditional marketing. To get the results they desire, artists must be clear with themselves in articulating the audiences to whom they wish to speak and in understanding the context from which they are addressing them.

III

Situations

In chapter one I described SEA as acting in the social realm—as carrying out a series of social actions. In chapter two I provided a general list of considerations that are useful to think about when making the decision to go out into the world to engage with people. In this chapter I will address a topic that is much more slippery: how to identify a variety of particular social scenarios and navigate the realm of shifting expectations and perceptions in a given community.

An artist—let's call her Joanna—is invited by the local arts council of a small American town—we'll call it Row Creek—to do an art project. Joanna wants to do a socially engaged project that will help empower the town's citizens and gain visibility for the area. She arranges for artist friends of hers to perform/install site-specific pieces in different storefronts and public spaces in the town over one weekend and calls the event the Row Creek Show.

The projects are conceptually intricate and many appear to be aimed more at an art world public than the townspeople, but the event acquires a big buzz, including reviews in the mainstream press. The residents, at first bewildered by the artworks, become excited by the media attention. The next year, the town wants to do another Row Creek Show. Joanna has moved on to other things and is not interested in reprising the project, and she tells the town leaders so. Very well, they say, we'll do it on our own, but this time we will have local artisans and craftspeople show their work. Joanna now has a conflict: barring returning to Row Creek and organizing the year's event herself, she must either entirely give up her authorship of the weekend and ask the town to disassociate her name with the project, losing credit for the original work, or become tangentially involved and endorse something that, to her, lacks artistic integrity. She can't make a strong case against extending the invitation to the craftspeople because the conceptual aspect of the original project was never discussed. What kind of miscommunication took place? Should Joanna have proceeded differently in the conception of the piece?

A second scenario: an international curator creates a series of artist residencies in an isolated indigenous community in Peru. He convinces the town to allow the artists to present a variety of projects there, and gives the artists free rein to respond to the local environment. The community members, who have a very distant or nonexistent relationship with art, find it hard to see the artists as more than crazy tourists or missionaries. The artists gradually decide to take an altruistic approach and start

doing things for the community: fixing roads, volunteering in social services, etc. The community is very appreciative, and the artist's projects, in varied degrees, help improve the life of the town. However, the curator and the artists share a sense that the experience, as beneficial as it was to the town, did not really create interesting or relevant artworks, which was the implicit goal. Did the artists sacrifice too much in the process?

A third scenario: an artist collective from New York City embarks on a road trip project, seeking to instigate a new revolutionary art movement. It plans to hold rallies in different American towns, inviting local artists to discuss and share ideas. Each stop will include a pep talk in the form of a manifesto reading and a discussion with the local artists about how they can effect change in their communities. The collective receives lots of institutional support for the project and secures a variety of spaces in which to do the presentations. It has no problem finding audiences; in most places, local artists are willing to attend the event and engage in a discussion. However, once the collective starts reading its inspirational manifesto, the local art communities view it with suspicion. The collective did not account for the possibility that New York is not necessarily viewed positively in a place like Tulsa and that artists in Tulsa, for example, may not necessarily wish to adhere to the New York art world's ideals nor appreciate being told what to do. In fact, most of the artists the collective encounters are perfectly happy working for themselves and in their own communities—so why create a revolution, for whom, and for what purpose? The artist

collective finds itself with lots of questions, uncertain as to how to proceed.

In these three scenarios—typical situations generated by SEA projects—artists inserted themselves in social environments with populations that usually had not called for their presence and are not expecting intervention via an art project. The key to a successful project lies in understanding the social context in which it will take place and how it will be negotiated with the participants or audience in question. When an artist enters one of these contexts, he or she is suddenly faced with complex and unfamiliar social dynamics expressed in terms and cultural codes different from the ones he or she is accustomed to. If any of these codes are misinterpreted, underestimated, or ignored, things can unfold in such a way that the artist soon feels lost or uncertain about how to proceed, and in some cases it can result in a very unproductive or negative experience for both participants and artist. So while it is not possible to predict the behavior of every individual or community, it is nonetheless essential to have a certain awareness of how interpersonal scenarios emerge and how some of them can be negotiated by developing a better understanding of the needs and interests of the parties involved.

SEA is concerned with situations, but not usually the kind in which a single individual interacts with an inert object. Rather, it concerns itself with situations that lead to a mode of social exchange—that is, interpersonal situations. The relation of individuals with each other through gains or confrontation is covered by social exchange

theory, a product of 1950s psychology and sociology that sees individual relations as based on a sort of social economy.* While it is not possible to perfectly translate human relationships into a set of economic parameters of supply and demand, social exchange theory does help us understand the complex underpinnings of a wide variety of types of social intercourse, and how outcomes are negotiated (known as outcome interdependence). As complex as individuals are, sociology and psychology have taught us that the vast majority of social situations conform to identifiable patterns. In 2003 a team of sociologists including Harold H. Kelley, John G. Holmes, Norbert L. Kerr, and others published *An Atlas of Interpersonal Situations*, a theoretical account that describes twenty-one of the most typical social situations and how we behave in negotiating them.† The diagrams in the book are very helpful in understanding the forces that shape the conflicts and potentialities in every social encounter. It is not possible here to discuss the many interpersonal scenarios introduced in the *Atlas*, but the artists' scenarios previously discussed can be best understood by using some of its parameters:

1. Corresponding versus conflicting interests. In the three examples, the interaction between artist(s) and community began as an enthusiastic encounter with what appeared to be a common goal: having

* See John W. Thibaut and Harold H. Kelley, *The Social Psychology of Groups* (New Brunswick, N.J.: Transaction Publishers, 1956).
† Harold Kelley, John G. Holmes, et al. *An Atlas of Interpersonal Situations* (Cambridge: Cambridge University Press, 2003).

a conversation, making a collaborative project, and improving a town. Very soon, however, the interests of the parties commenced to bifurcate: the people of Row Creek didn't care about the distinction between high and low art; the Peruvian villagers couldn't care less about art and have other, more practical needs; the local artists had no need for a revolution. In each one of those situations, the artists working on SEA were challenged with responding to emerging conflicting interests. They could choose to bend, to the point of sacrificing their own agendas, but it would mean abandoning their original plans.

2. Exchange problems. Either party initiates the project by offering something desirable for the other. For example, the New York City art collective offered an opportunity to each community it visited—a chance to improve its living conditions or its visibility or just simply a chance to have a discussion and a new set of experiences. In most instances, the artists did themselves have very clear expectations—they did not articulate what they wanted to get in exchange.

3. Information conditions. Conflict will often result if the parties each have different information or ideas about the situation and, therefore, different motivations; because information is not shared, the parties' actions are not necessarily welcome or echoed. For example, the curator in Peru was secretly hoping that the artists would create antagonistic work; because

he didn't share this with the artists instead he saw them making work that serviced the community in uncritical ways.

A common problem with SEA is that most communities don't understand what a conceptual artist does or the complex demands our profession makes on our activities—for example, documentation and its legal implications: if we videotape an activity, do the participants understand that their images may wind up in a museum collection? Also, more generally, most people don't consider social interaction to be part of the realm of art, and this can cause miscommunication. Part of the frustration felt by the organizers of the Peruvian residency program and the Row Creek Show was that they were unable to communicate the importance of regarding their activities as artwork and what that meant in terms of the engagement they were anticipating. While it is perhaps not possible or appropriate to explain the history of conceptual art to someone who is new to it, honesty and directness are important in establishing relationships of trust, and trust is key in engaging in productive activities with others.

Understanding new interpersonal situations and knowing how to operate within different scenarios is extremely difficult. Those who are professionally trained to deal with social situational variables (social workers, educators, psychologists, etc.) typically do so in constrained environments: a sixth-grade school teacher will be familiar with the variables of reactions and situations of a sixth-grade classroom; a museum educator will be familiar with an

audience's range of reactions in front of a particular painting; and so forth. In contrast, in SEA the variables are as multiple as the social environments and scenarios that an artist may decide to embark on, be it at a café in Vienna or a correctional facility in New Jersey. Yet this is precisely the value of SEA: artists—free agents—insert themselves into the most unexpected social environments in ways that break away from disciplinary boundaries, hoping to discover something in the process. It may take many years of this kind of work to find a true method to the madness of intruding upon and affecting environments whose populations do not always expect us; yet it is reassuring to know that, regardless of which country or space we are working in, human nature is universal, and social scenarios will begin to resonate in our memories for future reference. In the meantime, it is useful to recur to social work as a general reference, as long as it is understood that its tools are meant for a different kind of work. The contrast between the two is complex and must be analyzed carefully.

Social Work vs. Social Practice

A common inquiry I receive from art students regarding the relationship between social work and social practice often takes this form: "If I just want to help people, why should I call it art?" Conversely, a non-artist at a recent SEA conference I attended said to the speaker, "I have been unsuccessfully trying to create a business that supports sustainability. If I call it art, might I have a greater chance of success?"

These questions emerge from the perception that social work and social engaged art are interchangeable or at least that an action in one area may successfully become meaningful in another. It is true that in some cases a social work project that effects change in a positive manner in a community could also fall under the rubric of artwork. Similarly, an artist may share the same or similar values with a social worker—making some forms of SEA appear indistinguishable from social work, which further complicates the blurring between the two areas.

However, social work and SEA, while they operate in the same social ecosystems and can look strikingly similar, differ widely in their goals Social work is a value-based profession based on a tradition of beliefs and systems that aim for the betterment of humanity and support ideals such as social justice, the defense of human dignity and worth, and the strengthening of human relationships. An artist, in contrast, may subscribe to the same values but make work that ironizes, problematizes, and even enhances tensions around those subjects, in order to provoke reflection.

The traditional argument against equating SEA with social work is that to do so would subject art to direct instrumentalization, relinquishing a crucial aspect of art-making that demands self-reflexivity and criticality (remember the hypothetical children's community mural from the previous chapter). This argument, however, is weak; it precludes the possibility that art can be deliberately instrumental and intentionally abandon any hopes of self-reflexivity, ideas that some artists are interested in.

The stronger argument is that SEA has a double function that social work lacks. When we make a socially engaged artwork, we are not just offering a service to a community (assuming it is a service-oriented piece); we are proposing our action as a symbolic statement in the context of our cultural history (and/or art history) and entering into a larger artistic debate. Artist Paul Chan explicitly articulated his project *Waiting for Godot in New Orleans* (2007) as one that aimed to service the local community while also servicing the art world, in a quest to find a symbolic action that would reflect on issues raised by Hurricane Katrina—such as the social invisibility of a substantial segment of American society.* While SEA works do not have to be that explicit in their purpose, there is a always a clear desire by their authors to engage a second interlocutor (or "client," to use social work terminology), other than the community of participants—that is, the art world, which evaluates the project not just for what it has accomplished, but also as a symbolic action.

Some artists are adamant that their work blurs the boundaries between social work and art work, and others are not concerned whether their work is defined as art or non-art, thus taking a strictly noncommittal position. But in cases like the latter, the simple referencing of the possible dichotomy between art and non-art is already an acceptance that the activity is operating to a degree within the realm of art. Similarly, where the work appears, where the story is told, and if, whether, and how the artist

* See Paul Chan, *Waiting for Godot in New Orleans: A Field Guide*. New York: Creative Time, 2010.

"profits" from the work (whether just in the reputational economy or by selling objects related to the project as artworks) are telling signs of the work's relationship to art and the art world. Having established the distinction between social work and SEA, it is useful to now turn to the similarities between the forms. When an artist or a social worker enters in communication with an individual or a community, he or she will be confronted with the history (or lack thereof) of the individual or community with art or social issues, which will color the kind of experiences he or she will have as well as the initial nature of the exchange. Both social work and art practice are based on the postmodern perspective that it is the *perception* of facts, not facts in themselves, that matters. As such, the awareness by artists or social workers of the public's perception of them and of the situation is what should inform their way to approach a situation. In art, the awareness of others' perceptions is valuable in that it gives the artist tools to upset expectations either in positive or negative ways. Artists can benefit from learning how social workers inform themselves about a social environment and record local problems, hopes, and beliefs. Particularly in situations where artists need to earn the trust of a community, it is important to understand the mutual respect, inclusivity, and collaborative involvement that are main tenets of social work.

The next challenge is how to manage those scenarios once one has recognized them. In the examples given above, the projects, not unfolding as anticipated, have a

commonality: at some point in the exchange, there was a break in communication. In the following section, I will address a central medium of SEA: dialogue.

Conversation

In 1992, at the Café des Phares on place de la Bastille, Paris, a French philosopher named Marc Sautet started a series of two-hour Sunday gatherings during which anyone could join in philosophical discussion. Known as *cafés philosophiques* or *cafés philos*, they were meant to revive the Socratic dialogue by asking questions such as, "Is life worth living?" People from all walks of life participated, not just philosophers, and attendance reached two hundred. Despite Sautet's death in 1998, the concept has proliferated, and similar café events continue to take place in cities throughout the world, some under the name Socrates Café.

In Sautet's approach, as described by Christopher Phillips, who popularized the Socrates Café in the United States, the discussion structure differed from the Socratic method of dialogue, which is not truly horizontal.* A

* Christopher Phillips, *Socrates Café: A Fresh Taste of Philosophy*. New York: W.W. Norton and Company, 2001.

reader of the Platonic dialogues knows the hoops through which Socrates puts each one of his interlocutors, asking questions that suggest their own answers and cornering the perplexed student until the grand conclusion—apparently in Socrates's mind all along—emerges. Instead, a Socrates Café conversation is less a well-paved road to a predetermined conclusion and more of a meandering exchange that hopefully will lead to a somewhat satisfactory consensus.

Sautet's project was not meant to be SEA, but it could have been. Today hundreds of artists throughout the world use the process of conversation as their medium, for a variety of reasons, not least of which is the hopeful search for a collective conclusion around a particular issue.

Conversation is the center of sociality, of collective understanding and organization. Organized talks allow people to engage with others, create community, learn together, or simply share experiences without going any farther.

Grant Kester's book *Conversation Pieces* (2004) is a pivotal contribution to the recognition and validation of the existence and relevance of a dialogical art, which today is largely seen as a form of SEA. Further historical and theoretical grounding for dialogic practices has been addressed by scholars I have mentioned in previous sections of this book.

Nonetheless, there is not a lot of literature studying the dynamics of conversations taking place in contemporary art contexts. When a project based on conversational approaches is discussed, more emphasis is usually placed on the *fact* of that basis than on the content or structure of

the conversation or what the conversation *does*. (This is not to devalue work that is about creating the semblance of a conversation, which in itself may be interesting.) However, as I have emphasized in other sections of this book, in order to arrive at an intelligent, critical understanding of any practice or project, we must be able to evaluate the claims it makes against its actual operations, especially in the case of SEA. The need to reach greater clarity about the process of these works is necessary due to the fact that most projects that focus on conversation as a central component of the work tend to be subsumed with the generic and rather unhelpful umbrella label of "dialogic practices." If our intention is to truly understand verbal exchange with others as a tool, we must gain a nuanced understanding of the relationship between art and speech and reflect on the way in which one affects the other.

In my work in museums and in following the critical and curatorial discourses of contemporary art, I have always been struck by how little attention is given to dialogue or debate; instead, the exposition of theses through curatorial essays, public events, and art magazines is favored. (The closest thing to discussion in the art world is the interview, although this mechanism is used primarily to facilitate a monologue by an artist or other influential figure.) Real debates on issues of aesthetics are rare and are surprising when they occur. This indifference to the value of dialogue can possibly be explained by the influence of French postmodern philosophy (that of Michel Foucault, Jacques Derrida, etc.) on contemporary art theory, since these thinkers consider dialogue to be a flawed method

of communication, limited by power structures and logo-centrism. The tradition of education, in contrast, grew out of Hans-Georg Gadamer's hermeneutics, John Dewey's pragmatism, the neo-pragmatism of Jürgen Habermas and Richard Rorty, the pedagogy of Paulo Freire, and the work of others for whom the act of discussion is a process of emancipation. This thinking gives a clearer picture of the problems and potential of discussion in SEA.

Conversation is conveniently placed between pedagogy and art; historically, it has been seen not only as a key educational tool but also as a form of individual enrichment that requires as much expertise as any delicate craft. When people refer to the "lost art of conversation," they are affirming that verbal exchange requires expertise, imagination, creativity, wit, and knowledge. In a famous 1847 essay on the subject, Thomas de Quincey describes conversation as emerging from a need for a "colloquial commerce of thought" that would complement the power created by the "great commerce": "a power separate and *sui generis.*" It was apparent, he wrote, "that a great art must exist somewhere applicable to this power—not in the Pyramids, or in the tombs of Thebes, but in the unwrought quarries of men's minds, so many and so dark."* In other words, the art of conversation, when skillfully performed, is a form of enrichment.

The educated conversation described by de Quincey and the existential exchanges of the Socrates Café are

* Thomas de Quincey, "Conversation," in Horatio S. Krans, ed., *The Lost Art of Conversation: Selected Essays* (New York: Sturgis & Walton Company, 1910), p. 20.

but two examples of the myriad of ways in which verbal exchange takes form, described variously as dialogue, conversation, speech, talk, chat, or debate, depending on its level of formality. Yet, one could argue that, in the end, all forms of speech aim (explicitly or not) for the two basic goals of the Socrates Café and de Quincey's "art of conversation": truth and insight garnered through process. It is fairly well established that formal modes of speech (such as the political speech or the educational lecture) are the least sociable approaches.* While these can have a powerful effect on audiences, their main goal is conversion rather than exchange. This is why formal modes of presentation are employed by contemporary artists mainly for parody or as critique of the forms themselves (the performance lecture, for example), and as such the uses veer closer to the theatrical or performative. They are expositional formats.

SEA artists who seek to create a more convivial environment tend to favor less formal conversational structures. An artist may create a community space in which people are invited to discuss books; another may propose a town hall meeting; another makes himself available to have conversations on the street; yet another conducts a series of interviews among local residents. The objective in many cases is to eliminate formality and protocol, encourage participants to give, and, hopefully, arrive at interesting exchanges. (If, instead, boredom is the objective, it is an easy task to accomplish.) Yet in the vast majority of my

* See Donald Bligh, *What's the Use of Lectures?*, 1971.

conversations with artists, both established and emerging, I have found that their approaches to conducting such conversations are, for the most part, intuitive and based on trial and error. Open structures rely on spontaneity, which is hard to achieve. At a party we may have great conversations, or not—we don't know what we will encounter. Usually we try to gather with people we look forward to interacting with, and hope we will have good conversations. Informal exchanges can be unpredictable: they can be interesting, or they can lead nowhere.

The goal of an artwork may be to create a space in which *any* conversation can take place. In other cases, a work may exist simply to present the *semblance* of a meaningful conversation—where the idea of conversing, but not the conversation itself, matters. These latter works do not concern us here, as they are equivalent to the symbolic actions I discussed earlier, providing only illustrations of interaction.

In most dialogic art projects, however, artists are not satisfied with having just *any* conversation. Whether or not the conversation is the center of the work, the objectives usually are to arrive at a common understanding on a given subject, to raise awareness about a subject or problem, to debate a particular issue, or to collaborate on a final product. For better or worse, an artist must adhere to certain structures to attain a certain result. While experimentation can be positive, it is not necessary to blindly reinvent in art what is already an established practice in education.

Conversation has two variables: specificity of content and specificity of format. The following diagram outlines their interrelation:

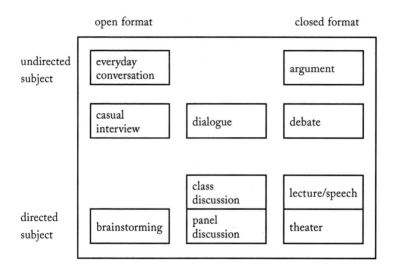

Depending on the structure of the subject and the format of a speech act, it can fall within recognizable formats, including the lecture, the debate, traditional theater, and casual conversation.

A greater level of direction and restriction of format in a speech act necessarily reduces the possibilities of interaction with an audience—participants in this situation are the most passive, as at a traditional theatrical production or a straightforward academic lecture, for example. In contrast, speech in open formats and about undirected subjects is, basically, most of our communication in everyday life: small talk and casual exchanges with people in

the street, for example. A brainstorming session is a fairly open format of exchange, usually with a directive or an objective: a group usually brainstorms to solve a problem, to come up with a new idea, or the like. The conjunctions of format and content outlined above result in familiar discursive models, none of which may suffice for an art project. In fact, many discursive art projects rely on shifting formats, oscillating between the formal presentation, the vivid debate, and the free-form conversation. However, the provisional divisions between formats may help in gaining a critical understanding of a particular project, different, perhaps, from what it appears to be at face value: it is fairly common for an art project to be described as a conversation or debate when it actually is more of a monologue or an unstructured chat. If one utilizes this general overview in analysis of art projects, it becomes fairly clear which discursive art projects operate under more or less conventional constraints.

Needless to say, if the objective is to have *any* conversation or to allow a verbal exchange to go off on a random tangent, not much is needed to accomplish the goal: the artist may basically let live events take over. However, when a project calls for a discussion centering on a particular goal or tries to arrive at a particular core consensus or agreement, the demand on the conversation leader is infinitely more complex, and—I would argue—far more rewarding. A well-conducted directed conversation relies on dialogic structure to arrive at mutual understanding and learning without losing the balance between interlocutors. For this to succeed, it is important for the instigator of

the discussion to know about the depth of engagement he or she is achieving with the audience.

Discussion-based teaching practices can be very helpful in determining the level of engagement among a group of interlocutors. One of the most popular means of gauging students' levels of engagement is the taxonomy developed by a large group of educators in the mid-twentieth century led by Benjamin Bloom. Bloom's taxonomy involves the following levels of understanding: 1. Knowledge; 2. Comprehension; 3. Application; 4. Analysis; 5. Synthesis; 6. Evaluation.* The first level (knowledge) is the stage at which students absorb facts or information. At higher levels, students are capable of assimilating knowledge and applying it to new situations and new problems. At the highest level, students are capable of understanding complex problems and collectively addressing them by providing possible solutions.

Bloom's taxonomy was developed for the classroom, which is different from the scenarios faced by an artist who works with a community, an activist group, or a random group of individuals. However, SEA places value on the depth of its intellectual effect on individuals, and so this taxonomy is relevant for artists, because it can help indicate the level at which our interlocutors are engaged in the project, what we can expect of them, and the significance of the impact we are having on their thinking and the impact they are having on ours.

* See John E. Henning, *The Art of Discussion-Based Teaching* (2008). New York:Routledge (pp. 18–21).

Participatory Dialogue and Mutual Interest

Opening a discursive space gives others the opportunity to insert their contents into the structure we have built. As this structure becomes more open, more freedom is given to the group to shape the exchange. The main challenge is to find the balance between the investment of the participants and the freedom provided. This means that when we open a structure of conversation, we should be prepared to accept participant input.

When SEA projects do not meet their objectives, it is often because the artist has not been attentive to the interests of the community and thus is unable to see the ways in which its members can contribute to an exchange. Many times, artists who are inexperienced in working with communities see them in a utilitarian capacity—that is, as opportunities by which they may develop their art practices—but they are ultimately uninterested in immersing themselves in the universe of the community, with all its interests and concerns.

This detachment of the artist may make the participants feel as if they are being used instead of like true partners in a dialogue or collaboration. In other words, the openness of the format and content of the project must be directly proportional to the level of genuine interest that the artist shows toward the experiences of the community and his or her desire to learn from these experiences. These are not traits that can be created artificially, and their existence is a true indicator of whether an artist is

suited to working with communities: it may be impossible to truly learn from others without having true curiosity about their lives and ideas.

If, however, the artist acts solely as agent and completely obeys the decisions and follows the interests of the community, he or she not only gives up the responsibility of creating a critical dialogue, but also proposes a dependent situation, in which the artist's job is only to solve a problem, as a professional technician—a common issue in social work as well. Ironically, although such gestures of service are usually well intentioned, they are in essence paternalistic and reflect the same lack of interest in open exchange as an artist who imposes his or her vision on a community. Artist and community must find the right balance of openness and mutual interest through direct communication.

This delicate negotiation is similar to the one between educator and student: artists and teachers both must demonstrate respect and a sincere interest in their interlocutors, but at the same time they need to construct relationships in which the exchanges are mutual and both parties offer help and contribute new insights, while still challenging their interlocutors' assumptions and demanding their investment in the exchange.

V

Collaboration

The notion of collaboration presupposes the sharing of responsibilities between parties in the creation of something new. In SEA, the tone of the collaboration is generally set by the artist, even when a community invites him or her to work with its members, because the artist is expected to be the conceptual director of the project. Collaboration in SEA is thus defined largely by the role the artist assumes. There are two main issues to consider in setting up that role: accountability and expertise. In both respects, Paulo Freire's critical pedagogy proves very helpful.

In working with Brazilian farmers in his successful literacy program in 1961 in Pernambuco, where Freire taught 300 sugarcane workers to read and write in 45 days,* Freire directly acknowledged the differences in knowledge and

* A useful reflection of this period is in Paulo Freire's 1994 book *Pedagogy of Hope*. New York: Continuum Books, 2004.

experience between himself and the farmers: he created a game in which he asked them a question about something they probably wouldn't know about, and vice versa. He first asked them if they knew, for example, who Plato was (they did not). Then the farmers asked him a question about agriculture, of which Freire knew nothing. In this way, Freire brought home the point that the differences in knowledge between the parties did not denote superior intelligence on either side but instead was connected to the difference in their environments, interests, and access to various opportunities.

In conversation with Freire, American educator Myles Horton once remarked: "my expertise is in knowing *not* to be an expert."* He meant that his role in his work consisted not in telling his students what they didn't know, but instead in helping them discover their own expertise and then decide for themselves what they needed to know. To simply provide them with information would, he felt, be patronizing and would create a pattern of dependency.

Certainly, the goal of critical pedagogy is not to create an artwork, but collaborative art also requires modes of communication that recognize the limitations and potentials of a collective relationship. Freire's approach provides a path to thinking about how an artist can engage with a community in a productive collaborative capacity.

* Paulo Freire and Myles Horton: *We Make the Road by Walking: Conversations on Education and Social Change* (p. 128). Philadelphia: Temple University Press, 1990.

Accountability

For a collaboration to be successful, the distribution of accountability between the artist and his or her collaborators must be articulated. Collaboration in SEA can range widely, from projects in which all decision making is done by the group to those in which the artist alone has complete control (a range exemplified by our hypothetical community mural project and the work of Santiago Sierra). Sierra's work is hardly a collaboration at all, as the product is highly controlled by the artist. In the case of the children's mural, at the other end of spectrum, the artist has very little accountability for the final product.

A false assumption that I have often encountered in discussions about SEA is that the artist can act as a neutral entity, an invisible catalyst of experiences. When a professional artist or arts educator interacts or collaborates with community with little previous involvement with art, the community has an undeniable disadvantage in experience and knowledge, as long as the relationship unfolds primarily in the art terrain. In this case, the artist is a teacher, leader, artistic director, boss, instigator, and benefactor, and these roles must be assumed fully. There are artists who try to be merely facilitators, to the point of denying that they are using any individual initiative at all. Claire Bishop characterizes this as an attempt at the "elimination of authorship," grounded in anticapitalist premises and in

a sort of Catholic altruism, a way to redeem the guilt of social privilege.*
But the artist cannot disappear. As I have shown in previous sections, while authorship in SEA may be different than in other forms of art, it cannot be altogether eliminated.

Expertise

The tendency to try to act as mere facilitator is connected to another source of confusion about the role of the artist in a collaborative relationship: that of not understanding where one's expertise lies. These doubts generally emerge from a sincere puzzlement among artists, who feel that in SEA they are merely "playing" among various disciplines. This leads to the question, from students, "Should I dedicate myself to a useful social profession instead of making art?"

The expertise of the artist lies, like Freire's, in being a non-expert, a provider of frameworks on which experiences can form and sometimes be directed and channeled to generate new insights around a particular issue.

Frameworks of Collaboration

In every SEA project, the level of input expected from the community must be defined. As discussed above, it should be proportionate to the community's investment in the

* Claire Bishop, *The Social Turn: Collaboration and its Discontents.* Artforum, February 2006 pp. 179–185.

project and to the responsibility it is assigned in it. It is unrealistic to demand a lot of participation or work from collaborators who are not also part of the decision-making process, without creating other incentives to make them feel ownership of the project. While a group overall may be eager to participate for the sake of the experience, it is not likely that all participants will be willing to truly invest without a clear incentive.

However, if the community makes all the decisions, the artist is operating merely as a service agent. This relationship reduces art practice to yet another form of social welfare, similar to that of the above-mentioned children's mural—a feel-good action that doesn't truly create a meaningful framework for reflection or critical exchange.

Thus, to enter a collaborative process with a community requires a reflection on the terms under which the artist and the group will interact. This is a difficult task, and it tends to generate anxiety for the artist, who is under pressure to provide a strong framework for interaction while making a work that is conceptually original, provocative, and distinctive. Both goals are hard to accomplish by themselves, and the complication escalates once we bring more people into the picture, with their own ideas and interests.

What must be recognized, first, is the value that individuals bring to a collaboration. Each individual has his or her own expertise and interests, and when these are put to service in the collaboration, the collective motivation can be contagious. Second, we need to create frameworks that are not completely predetermined in theme or structure,

as an overly predetermined plan will likely not allow for the input of potential collaborators; they may feel that they can't put their own expertise and interests to use. Open Space Technology (OST), a form of collective brainstorming, can prove very beneficial in understanding the needs and interests of a group. This approach for managing a collective meeting was invented by consultant Harrison Owen in the mid-1980s. OST is designed to address a real and tangible problem with a group that is invested in solving it. After an initial brainstorming session, in which an overall agenda is created, a variety of breakout sessions are formed, composed of those most invested in individual topics (with the option to move to another conversation if they wish to do so). Although OST was developed for situations common in the corporate world, it can prove very useful where an artist is trying to understand the issues that concern a group of people and to develop a project around them. Owen's self-explanatory statements about the process may be particularly helpful: "Whoever shows up is the right person," and "When it's over, it's over."

Collaborative Environment

Reggio Emilia schools are famous for the beauty of their surroundings and the multisensorial appeal of their classrooms. The philosophy is that a stimulating learning environment (visually and in other respects) promotes creativity. Of the components of SEA, the collaborative environment may receive the least attention. Usually

because of lack of resources or similar constraints, meetings or workshops tend to be conducted in whatever space is available. Today it is a cliché to see the barren space of a kunsthalle gallery filled with wooden tables, chairs, and publications, presumably for the visitor to peruse; this is considered an "activation" of the space.

Most of us in our SEA projects are unable to recreate the idyllic environment of a beautiful house in northern Italy. However, small gestures (such as providing food and a comfortable space) can go a long way in encouraging conviviality. The challenge for an artist is how to adapt successful models—such as that of Reggio Emilia—to the realities and possibilities of the environment he or she is working in.

Antagonism

So far in this book I have addressed approaches and strategies that favor congenial experiences: dialogue and collaboration are, for the most part, activities of agreement. However, the antisocial or antagonistic social action is a fundamental area of activity in SEA. Some artworks are particularly obvious in their confrontational nature, but the fact is that all art that seeks to advance the dialogue on an issue features a degree of disagreement or a critical stance. It is wrong, therefore, to create a division between controversial or confrontational works and non-controversial ones. Antagonism is not a genre but rather a quality of art-making that is simply more exacerbated in some practices than in others.

Confrontation implies taking a critical position on a given issue without necessarily proposing an alternative. Its greatest strength is in raising questions, not in providing answers. Many confrontational strategies adopted

by SEA artists today are historically indebted to artists associated with institutional critique, such as Michael Asher, Marcel Broodthaers, Andrea Fraser, Hans Haacke, and Fred Wilson. Focusing mostly on the institutional frameworks of art, these artists exposed power structures in their works, adopting at times ironic, humorous, provocative, or openly antagonistic stances.

In the case of Santiago Sierra, the contemporary art world recognizes his actions as significant conceptual statements because, as much as some may object to his work, confrontation, as a mode of operation, is instinctively recognized by those familiar with the vocabulary of art. Sierra's works are at home in a long history of antagonism in art. They make direct reference to Minimalism and performance art and also align with the rebellious and at times antisocial actions that have propelled the avant-garde.

In some ways a confrontational artwork is easier to orchestrate than one that requires many hours of negotiation, consensus building, and collaboration with a community. After all, it is expedient to pay someone to do a task or to subject a group of people to an experience without their consent than to hold a series of long meetings, as often happens in collaborative community art projects. However, a negative approach faces its own series of hurdles: for example, an antagonistic action might be regarded as so alienating that it is dismissed as hostile for no good reason. This is why it is useful to understand the general ways in which a confrontational approach may be taken and how it may engage with a group of people.

Antagonistic approaches engage audiences under the same categories of participation outlined previously:

Voluntary. Participants willingly submit themselves to the action, out of their own interest or because there is an ulterior purpose for doing so. (In Sierra's work the interaction is based on a financial transaction, bringing the project closer to a directed performance.)

Nonvoluntary. Participants find themselves in the middle of the action without having previously consented to it. Activist groups, protest art and other guerrilla practices would fit within this category. An example would be the work *The Couple in the Cage* (1992) by Guillermo Gómez-Peña and Coco Fusco, where they exhibited themselves inside a cage at natural history museums as recently "discovered" Amerindians, providing an aura of interpretive authenticity that disguised the artwork as a real exhibition, and provoked audiences to react to the piece as if this exhibition of human beings was a real situation.

Involuntary. The participant unexpectedly finds herself in the middle of a situation after being initially enticed to engage in some activity. For example, in 1968 Argentinean artist Graciela Carnevale made a work that consisted of locking visitors to an opening reception inside the gallery. Visitors willingly attended the event but were not aware that they would be locked inside the space.

The greatest difference in these scenarios is the kind of relationship between the artist and the participants and the discussion that takes place between them concerning the action to take place. In the case of the simple imposition of an experience (nonvoluntary), no negotiation is allowed. In a voluntary relationship, there is a clear-cut agreement (such as a contract) between the parties. With involuntary participation, negotiation is the most subtle and difficult to do, because in these cases deceit or seduction plays a central role in the work. In these instances, participants (be they the unwitting audience of an event or direct collaborators) at first willingly engage but later become involuntary participants or actors in a SEA experience. Involuntary confrontational tactics closely simulate culture jamming, a practice of anti-consumerist activists. The Yes Men, a duo of activists who trick the media and corporations into participating in fictional schemes that expose their questionable practices, are a well-known example of culture jamming. The enticement approach is a bit of a mind game, in which audiences and participants are placed in environments that compel them to engage in a particular way, not realizing until later that they are inside an artwork of which they are the subjects.

In May of 2003 a group of artists—to which I belonged—conducted such an experiment in Mexico City, in response to the increasingly conservative climate of government-run cultural policy (or lack thereof) in Mexico.*

* *Primer Congreso de Purificación Cultural Urbana de la ciudad de México* (First Mexico City Congress of Urban Purification). Done in collaboration with artist Ilana Boltvinik as part of the X Teresa performance festival, Mexico City, 2003.

La Jornada newpaper, July 13, 2003

The project took the form of a daylong conference in the Gran Hotel Ciudad de México. The event was publicized not as an art project but as a real conference, with a call for papers about cultural policy. Of the submissions received, six were selected for the conference; six others were scripted by the artists and read by actors, unbeknownst to the audience. The six scripted presentations formulated points of view that are rarely expressed in academic or public forums. One called for the complete elimination of national arts funding, arguing that too much goes to support the bureaucratic apparatus and too little to actual art-making. Another paper—read by performance artist Ryan Hill, who was introduced as director of a conservative American organization—proposed a U.S.-run cultural

policy program for Mexico. It generated an outraged media blitz in various Mexican newspapers, which in turn led to a public debate on cultural policy, as originally intended by the organizers. After a few days it emerged that the event may have been a performance, but it remained unclear what elements had been fabricated. When pressed, we released a statement to the effect that whether or not the views in the symposium had been expressed by actors or real-life people didn't alter the substance of the debate. In our view, to have declared the event or part of it a performance would have allowed some people to dismiss it as "just art."

The implicit logic of the confrontational approach is that certain statements cannot be negotiated openly or directly with the public, and so people have to be forced into the experience through a series of steps that are firmly in control of the artist. Many of the works in this category are politically motivated and comment on issues through bold actions.

The approach has some distinctive qualities:

1. Antagonistic SEA rarely aspires for complete alienation but rather aims to create a line of discussion around a relevant issue, provoking reflection and debate and therefore justifying its extreme measures.

2. To make a statement that is not altogether alienating, such works must find a balance between means and ends. A very violent and aggressive approach is more likely to be tolerated when the point is equally grave; otherwise it may be regarded as arbitrary and

unnecessary. This is why many of the memorable artworks made in this way make a direct reference to a very serious political or social issue. Cildo Meireles's controversial 1971 performance *Tiradentes: Totem-Monument to the Political Prisoner* consisted in tying ten live chickens to a spike and setting them on fire. If the piece had not been a direct comment on the brutal military regime in Brazil, the action may not have allowed some to oversee the moral implications of slaughtering the animals. Cuban artist Tania Bruguera creates similar confrontational scenarios in her work—such as having served cocaine during a lecture in Bogotá in 2009.*

3. It is clear that the perception and assimilation (or rejection) of these kinds of actions are dependent on the time and place in which they occur; what pushes the envelope just enough in one context may not do so in another.

4. Finally, antagonism can also manifest itself in the self-representation of the action. Many SEA projects that proclaim themselves to be collaborations but actually are symbolic actions (as previously discussed) are antagonistic in essence, as they present themselves as something they are not. This slight manipulation is another vehicle for confrontation, for whatever purposes it may serve.

* See article *Tania Bruguera, que sirvió cocaina en un performance, suele hacer montajes polémicos.* Diario El Tiempo, Bogotá, September 11, 2009.

VII

Performance

In medieval France, a popular celebration known as the Feast of the Ass was held on January 14 to celebrate the flight of Mary and Joseph and the infant Jesus into Egypt as related in the Bible. A donkey was led into the church to preside in the mass. Similar in nature to the Feast of Fools, the Feast of the Ass incorporated a temporary change in social roles, in which those in subordinate positions could act as authorities, the old could act young, men could act as women, and so forth, culminating with the lowly beast becoming the highest power. In contemporary art theory—and usually in describing relational works—the most familiar articulation of this idea is that of literary theorist Mikhail Bakhtin, who described this cultural inversion as "the carnivalesque," in which social hierarchies are temporarily broken through satire, celebration, and chaos.*

* See Mikhail Bakhtin [1941, 1965], *Rabelais and His World* (Bloomington: Indiana University Press, 1993).

Performance is embedded in SEA, not only because SEA is performative but because it borrows from several conceptual mechanisms and strategies that are derived from the history of performance art. As such, SEA confronts many of the issues that also belong to performance art, including the role of documentation (which will be discussed in the following chapter) and the relationship to spectacle and to entertainment. It is useful to ascertain what strategies of performance art are at play in SEA in order to get a better understanding of them.

Many SEA projects are activist in spirit or seek to make strong social or political statements, making their agenda unambiguous. However, some SEA projects don't have declared aspirations other than to engage audiences in unexpected experiences. Many museums have jumped on the bandwagon of SEA, bringing artists in to enliven their mostly unlively galleries and offer activities that may engage their visitors. These efforts, while almost always valuable to a degree, blur the boundaries between an artist's gesture and a face-painting event for members. It raises a question: How can we determine the point at which a socially engaged work becomes subservient to a particular cause to the point of being purely entertaining? What is our goal when we engage playfully with an audience? Is it enough to create ephemeral, entertaining, or confrontational gestures, regardless of whether or to what degree they reach the consciousness of individuals or communities?

The problem is difficult to address because each artwork presents a different situation, but it may be helpful to look

at performance art's relationship with spectacle and art education, which has its own familiar dilemma in this respect, often referred to as the problem of *edutainment*. As has been observed in the recent emergence of performance art festivals, the definition of the genre is so fluid that it is nearly impossible to restrict it to a particular form of live presentation. Performance can be a spectacle and still be consistent in its relationship with the history of art, which is arguably the reason why it should be connected to the practice. However, the spectacle presented in performance art is usually the means, not the end, of the activity. This is to say that when a performance appears to be merely a great spectacle, there is usually more than meets the eye—namely, a critique of spectacle embedded in the spectacle itself.

In education, spectacle is also meant to be the means, not the end, of an activity. We all recognize the attraction of theater, music, and dance, and audiences are usually comfortable with assuming the role of spectators. The critique that education-generated spectacles often receive—when they are pejoratively called "edutainment"—is that the supposed critical substance of the event has been diluted into an essentially commonplace spectacle far removed from the goals of education.

The same principles that apply to both performance and education apply to SEA. Magicians, clowns, and mimes are not usually considered contemporary artists, yet they are wonderful sources of entertainment to audiences. If, as artists, the aspiration of an SEA project is merely to entertain the public, even through less orthodox means,

it is hard to make a case for it as a meaningful artistic exploration. Yet, it is important to retain an aspect of play in SEA and be aware of its performative function in social interactions. However, it is only when play upsets, even if temporarily, the existing social values (Bakhtin's "carnivalesque") that room is created for reflection, escaping the merely hedonistic experience of spectacle.

Because of the strengths of the communities created through such performative experiments, in them authorship is tenuous at best and the process of exchange is so important that an outcome visible to an outside observer— "the product," in an art market sense—may not be that relevant or even materialize. Finally, the boundaries between artwork and experience are blurred, in the same way that authorship and collectivity are blended, documentation and literature are one, and fiction is turned into real experience and vice versa. All components of a traditional structure of production and interpretation are turned around and resignified. Nonetheless, this resignification rarely is done for its own sake—we could call it a Feast of the Ass with an agenda. Because of the insertion of the pedagogical element, the exchanges that take place in these experiences are constructive, in a direct or indirect fashion. Artists take their tactics from the replication of institutional structures, but allowing carnivalesque interactions both validates the experience as an artwork and still manages to remain constructive. The Feast of the Ass is not only an inversion of social roles but of meanings and interpretations within a discipline, conflating them,

at times letting them cancel each other out, and at times joining them in progressive ways, constructing models of interactions that other disciplines are too shy or reluctant to try. What art-making has to offer is not accurate representation but rather the complication of readings so that we can discover new questions. It is when we position ourselves in those tentative locations, and when we persist in making them into concrete experiences, that interstices become locations of meaning.

VIII

Documentation

Authorship hinges on the existence of a recognizable product. It is hard to claim to be an author of any kind if there is no tangible product to claim as one's own. Yet that is precisely what lies at the center of SEA: the idea that an intangible social interaction between a group of people can constitute the core of an artwork. Documentation, often taking the place of an end product, helps reinforce the presence of an authorial hand—for example, the copyright of a photograph of a collective action belongs, usually, to the artist. But what happens when the artist is the sole author of the documentation of a collective action?

In contemporary art and in art history in general, the voice of the public is generally missing; it is the voice of the artists, the curators, and the critics that appears to matter. Yet in projects where the experience of a group of participants lies at the core of the work, it seems incongruous not to record their responses. If these individuals

were the primary recipients of a transformative experience, it should reside within them to describe it, not the artist, critic, or curator. The critic, in exchange, should function as an interpreter of those accounts but not the primary reporter of them, unless he or she has been an active participant.

In SEA, it is important to address the role that documentation plays in the work by thinking both about its relationship with the parent form—performance art—and with the participatory public. In their own descriptions, artists commonly blur the line between what actually happened and what he or she wished had happened (which normally results in presenting a symbolic action as actual, as previously defined). Whether the blurring gesture is a claim for autonomy or a response to the fear of being pinned down and called to task for what he or she has done is of little relevance: the bottom line is that a work that shows little concern for verifiable documentation can't be considered to be more than a work of fiction—a symbolic piece.

The tendency to use documentation as proof of a practice and as the relic of a work may be related to the legacy of the action-based art of the 1970s. Documentation of those performance actions generally consists of a film or video or a series of photographs of what happened as well as word-of-mouth accounts, written descriptions, and interviews. We "know"—or at least are sufficiently persuaded—by images and personal accounts that Chris Burden did have himself shot, and the reality of the event is important to us. The photographs and films may

become relics, artworks in themselves, or surrogates for the original work, but in all three cases they retain some aspect of "product" and, as such, a direct connection to a product maker—that is, an author. Documentation in SEA, if the goal is to be objective and verifiable, should not be an exclusive extension of the author for a number of reasons. To bring Jürgen Habermas one more time into the discussion: if we accept that SEA is a type of communicative action—the result of an intersubjective dynamic—it is incongruous that its documentation be only the one-sided account of the artist. If I organize a collective action and then describe and illustrate it on my own, however I want, I am taking an instrumentalizing approach to what in theory was a collective experience. Habermas would argue that, as someone who was embedded in the action, an artist—even if acting in good faith and making efforts to be objective in representing what happened—is a subject of the action, and as such we can't rely on his or her descriptions: they may be delusional about the artist, the project, and its relationship with the world. Most performance historians take this as a given, even art historians who try to reconstruct performances, exhibitions, and other ephemeral events, recognizing that the memories or perspective of an artist may be skewed for a great variety of reasons.

Similarly, documentation should be regarded as an inextricable component of an action, one which, ideally, becomes a quotidian and evolving component of the event, not an element of postproduction but a coproduction of viewers, interpreters, and narrators. Multiple witness

accounts, different modes of documentation, and, most importantly, a public record of the evolution of the project in real time are ways to present an event in its multiple angles and allow for multiple interpretations. SEA documentation must be understood and utilized in full recognition of its inadequacy as a surrogate for the actual experience (unless it is meant to be the final product, in which case the work would not be SEA). Documentation of a particular action or activity is usually displayed in a traditional exhibition format, in which it is allowed to narrate the experience. While it may be informative, this approach is frustrating to the gallery visitor, who is exposed to a representation of the experience and not to the experience itself. In this regard, criticisms of SEA as presented in conventional exhibitions are well founded. SEA can't evoke the immediacy of a collective experience in gallery goers by presenting a video recording of it. Whatever they end up experiencing in such a case is just that—a video or a set of photographs; if such documents are presented as artworks then they may be scrutinized as a video installation or conceptual photograph but not as the social experience they may have intended to communicate.

Transpedagogy

In this book I have discussed SEA primarily through the lens of pedagogy. For that reason, it is particularly relevant to acknowledge that a substantial portion of SEA projects explicitly describe themselves as pedagogical. In 2006 I proposed the term "Transpedagogy" to refer to projects by artists and collectives that blend educational processes and art-making in works that offer an experience that is clearly different from conventional art academies or formal art education.* The term emerged out of the necessity to describe a common denominator in the work of a number of artists that escaped the usual definitions used around participatory art.

In contrast to the discipline of art education, which traditionally focuses on the interpretation of art or teaching

* See Helguera, "Notes Toward a Transpedagogy," in *Art, Architecture and Pedagogy: Experiments in Learning,* Ken Erlich, Editor. Los Angeles: Viralnet.net, 2010.

art-making skills, in Transpedagogy the pedagogical pro-
cess is the core of the artwork. Such works create their own
autonomous environment, mostly outside of any academic
or institutional framework. It is important to set aside, as I have done in previous
sections, the symbolic practices of education and those
practices that propose a rethinking of education through
art only in theory but not in practice.
Education-as-art projects may appear contradictory
through the lens of strict pedagogy. They often aim to
democratize viewers, making them partners, participants,
or collaborators in the construction of the work, yet also
retain the opacity of meaning common in contemporary
art vocabularies. It goes against the nature of an artwork
to explain itself, and yet this is precisely what educators
do in lessons or curriculum—thus the clash of disciplinary
goals. In other words, artists, curators, and critics liberally
employ the term "pedagogy" when speaking of these kinds
of projects, but they are reluctant to subject the work to
the standard evaluative structures of education science.
Where this dichotomy is accepted, we are contenting
ourselves with mimesis or simulacra—we pretend that
we use education or pedagogy, but we do not actually use
them—returning to the differentiation of symbolic and
actual action discussed in previous chapters. When an art
project presents itself as a school or a workshop, we must
ask what, specifically, is being taught or learned, and how.
Conversely, if the experience is meant to be a simulation
or illustration of education, it is inappropriate to discuss
it as an actual educational project.

Second, it is necessary to ask whether a project of this nature offers new pedagogical approaches in art. If an educational project purports to critique conventional notions of pedagogy, as it is often claimed or desired, we must ask in what terms this critique is being articulated. This is particularly important, because artists often work from a series of misperceptions around education that prevent the development of truly thoughtful or critical contributions.

The field of education has the misfortune, perhaps well earned, of being represented by the mainstream as restrictive, controlling, and homogenizing. And it is true that there are plenty of places where old-fashioned forms of education still operate, where art history is recitation, where biographical anecdotes are presented as evidence to reveal the meaning of a work, and where educators seem to condescend to, patronize, or infantilize their audience. This is the kind of education that thinker Ivan Illich critiqued in his 1971 book *Deschooling Society*. In it Illich argues for a radical dismantling of the school system in all its institutionalized forms, which he considers an oppressive regime. Forty years after its publication, what was a progressive leftist idea has, ironically, become appealing to neoliberals and the conservative right. The dismantling of the structures of education is today allied with the principles of deregulation and a free market, a disavowal of the civic responsibility to provide learning structures to those who need them the most and a reinforcement of elitism. To turn education into a self-selective process in contemporary art only reinforces the elitist tendencies of the art world.

In reality, education today is fueled by the progressive ideas discussed above, ranging from critical pedagogy and inquiry-based learning to the exploration of creativity in early childhood. For this reason it is important to understand the existing structures of education and to learn how to innovate with them. To critique, for example, the old-fashioned boarding school system of memorization today would be equivalent, in the art world, to mounting a fierce attack on a nineteenth-century art movement; a project that offers an alternative to an old model is in dialogue with the past and not with the future.

Once we set aside these all-too-common pitfalls in SEA's embrace of education, we encounter myriad art projects that engage with pedagogy in a deep and creative way, proposing potentially exciting directions.

I think of the somewhat recent fascination in contemporary art with education as "pedagogy in the expanded field," to adapt Rosalind Krauss's famous description of postmodern sculpture. In the expanded field of pedagogy in art, the practice of education is no longer restricted to its traditional activities, namely art instruction (for artists), connoisseurship (for art historians and curators), and interpretation (for the general public). Traditional pedagogy fails to recognize three things: first, the creative performativity of the act of education; second, the fact that the collective construction of an art milieu, with artworks and ideas, is a collective construction of knowledge; and third, the fact that knowledge of art does not end in knowing the artwork but is a tool for understanding the world.

Organizations like the Center for Land Use Interpretation, in Los Angeles, which straddle art practice, education, and research, utilize art formats and processes as pedagogical vehicles. The very distancing that some collectives take from art and the blurring of boundaries between disciplines indicate an emerging form of artmaking in which art does not point at itself but instead focuses on the social process of exchange. This is a powerful and positive reenvisioning of education that can only happen in art, as it depends on art's unique patterns of performativity, experience, and exploration of ambiguity.

Deskilling

Assuming that socially engaged art requires a new set of skills and knowledge, art programs engaged in supporting the practice have quickly begun to dismantle the old art school curriculum, which is based on craft and skills—ranging from what remained of the academic model (figure drawing, casting, and the like) to the legacy of the Bauhaus (such as color theory and graphic design). What is replacing it is tenuous at best, and the process often creates a vacuum in which the possibilities are so endless that it can be paralyzing for a beginning practitioner. The social realm is as vast as the human world, and every artistic approach to it requires knowledge that can't be attained in a short period of time. This is, perhaps, the main reason why students often wonder whether an SEA practitioner can be any kind of expert. Disenchanted with poor guidance and with no sense of purpose, students

may turn to a social work discipline instead, leaving the conventional tools of art behind. Some believe that it is the future role of art to dissolve into other disciplines; I think such a dissolution would be the product of poor education about what the dialogue between art and the world can be.

The underlying issue is, of course, the crisis of higher education in the visual arts, which involves far more complex problems than what we can address here. I will, however, point out some problems in the traditional curriculum that should be taken into consideration in a discussion about teaching and learning SEA.

In a traditional art school, the emphasis on craft and the subdivision of departments (sculpture, painting, ceramics, etc.) promotes the development of specialties that each bases its discursivity in a discussion about itself. In this framework, artworks are judged by how they question or push notions intrinsic to the craft, an approach that enters into conflict with the direction Post-Minimalist practices have taken, including SEA. In them, craft is placed at the service of the concept, not the other way around. Furthermore, the promotion of a craft specialty makes it difficult for an artist to achieve a critical distance from his or her work.

The disconnect between art programs and art practice is another problem. In an art school, the school itself is the primary context in which the art will be produced and analyzed. This artificial environment, while necessary and positive in some aspects—such as the social environment

it creates for artists of the same generation and interests—
too often is not challenging enough or does not provide
students with a clear understanding of the world in which
professional art activity takes place.* The lack of distance from craft, the use of historical
forms of art as the guidelines for future art-making, and
the absence of practical experience may inspire an impulse
to dispense with historical art disciplines completely and
instead give the students an open field in which to play.
However, this dismantling, deskilling, or "deschooling"
(to use Ivan Illich's term) soon can become chaotic and
aimless. Something must take its place.

It may take years to establish the best way to nour-
ish SEA practices. In this book I have made a case for
education processes as the most beneficial tools for fur-
thering the understanding and execution of SEA projects.
However, any new art curriculum for SEA needs to be
multidisciplinary in its reach and creative in its individual
development.

Christine Hill is an artist whose work ranges from
small editions to the exploration of social transactions
through her project Volksboutique. She chairs the new
media program at the Bauhaus-Universität Weimar where

* In 2005, I wrote *The Pablo Helguera Manual of Contemporary Art Style*
(Tumbona Ediciones, Mexico City) a critique of the social dynamics
of the art world. I hoped it would serve as a practical guide for art
students in understanding the underlying social system in which art
is evaluated and supported. Little effort has been made in schools
to prepare art students to engage in the social terms of the art scene
and thus lessen the great anxiety of a young artist facing the world at
large for the first time.

she has created a course entitled "Skill Set" in which students learn a series of non-art skills for which they also transform our studio/classroom space into a suitable environment for the task. The skills taught have included 50s hair styling, Alexander technique, stenography, and Japanese tea ceremony, amongst many others, as they change every year. While the program retains the idea that artmaking requires technical knowledge, it emphasizes the value that any non-art specialty may bring to the art and design practice. In Hill's own words about the objective of the course: "The notion is for them to rely on their own resources (i.e., not to just spend money to recreate something) and [develop the] ability to innovate as designers, and involves a tight enough deadline system so that they are pretty much working non-stop on these installation rotations . . . like flexing a muscle repeatedly."*

The new art school curriculum (or a self-guided program for someone interested in SEA) should contain these four components:

1. A comprehensive understanding of the methodological approaches of socially centered disciplines, including sociology, theater, education, ethnography, and communication;

2. The possibility of reconstructing and reconfiguring itself according to the needs and interest of the students;

* Correspondence with Christine Hill, July 12, 2011.

3. An experiential approach toward art in the world that offers a stimulating challenge to the student;

4. A refunctioned curriculum of art history and art technique, including a history of the way these things have been taught in the past.

Implementing these four components would require a significant rethinking of how curriculum is constructed in a university or art school (particularly the bureaucratic process). As in the Reggio Emilia Approach, the curriculum would not be a monolithic schedule of subjects but the result of an organic exchange between professors and students, in which the former listen to the interests of the latter and use their expertise to construct a pedagogical structure that will serve their needs. Some basic tenets must be maintained, which would form part of the third objective, providing the student with a sense of the real world so that he or she understands that contexts are not always under the artist's control.

It may seem counterintuitive to seek a reintroduction of the traditional components of studio art and art history, and it definitely is contrary to the direction of social practice programs today, which are severing their links to studio programs. Yet that division is, I believe, unnecessary and limiting. As I have argued throughout this book, the disavowal of art in SEA to the extent that it is even possible, at best weakens the practice and brings it closer to simulating other disciplines. If we understand the history

of the forms of art, the ideas that fueled them, and the ways these ideas were communicated to others, we can transpose and repurpose them to build more complex, thoughtful, and enduring experiences.

Acknowledgments

I wrote this book in 2010–11 while developing two socially engaged art projects, one in Bologna (*Ælia Media*) and the other in Porto Alegre, Brazil (the pedagogical project of the 8th Mercosul Biennial). Working back and forth between two countries that gave so much to the field of education (the work of Paulo Freire and Augusto Boal in Brazil and the Reggio Emilia school system in Italy, just to name a few) certainly colored some of the thoughts presented here. But, most importantly, it was the teams of collaborators with whom I developed those projects (Julia Draganovic and Claudia Loeffelholz in Bologna, and Mónica Hoff and Gabriela Silva in Porto Alegre), that taught me the most and helped me to articulate my thoughts.

This book is also the result of many conversations, debates, and exchanges over the course of several years with artist and educator colleagues, curators, and writers. I am particularly grateful to Claire Bishop, Tom Finkelpearl, Shannon Jackson, and Suzanne Lacy, who, with great generosity, agreed to read this book in its different drafts and provide their feedback and comments. I am certain that this book is better because of them; any shortcomings of the text reflect my inability to fully heed their wise and expert advice.

I can only mention a few of the many others with whom I had exchanges that informed my thinking for this

book: Mark Allen, Tania Bruguera, Rika Burnham, Luis Camnitzer, Mark Dion, James Elkins, Harrell Fletcher, Kate Fowle, Hope Ginsburg, Sam Gould, Fritz Haeg, Christine Hill, Michelle Jubin, Sofía Olascoaga, Morgan J. Puett, Ted Purves, Paul Ramirez-Jonas, John Spiak, and Sally Tallant. I am always indebted to Wendy Woon and my colleagues in the Department of Education at the Museum of Modern Art, New York, with whom I share an ongoing dialogue about many of these issues. I also want to thank my students at Portland State University, Oregon, who were my main interlocutors in the development of some of these ideas: Dillon de Give, Aysha Shaw, Travis Souza, and Transformazium, a collective composed of Dana Bishop-Root, Callie Currie, Leslie Stem, and Ruthie Stringer.

About the Author

Pablo Helguera (born in Mexico City in 1971) is a visual and performance artist. Past art projects have included a phonographic archive of dying languages, a memory theater, fourteen visual artist "heteronyms," and four fictional opera composers. Helguera is the author of nine previous books, including *The Pablo Helguera Manual of Contemporary Art Style* (2005, English version 2007), *The Witches of Tepoztlán (and Other Unpublished Operas)* (2007), the novel *The Boy Inside the Letter* (2008), *Artoons I* and *II* (2009), the play *The Juvenal Players* (2009), the anthology of performance texts *Theatrum Anatomicum (and other Performance Lectures)* (2009), *What in the World* (2010)—a "subjective biography" of the Penn Museum in Philadelphia—and the novella *Urÿonstelaii* (2010). In 2006 he drove from Anchorage to Tierra del Fuego with a collapsible schoolhouse, organizing discussions, activist happenings, and civic ceremonies along the way (*The School of Panamerican Unrest*). He has been the recipient of Creative Capital, Guggenheim, and Franklin Furnace fellowships, and in 2011 he was the first recipient of the International Award for Participatory Art, given by the Assembly of Emiglia-Romagna, in Italy. In 2011 he was pedagogical curator of the 8th Mercosul Biennial in Porto Alegre, Brazil. Since 2007 Helguera has been Director of Adult and Academic Programs in the Department of Education at the Museum of Modern Art, New York. He is married to artist Dannielle Tegeder, and they live in Brooklyn with their daughter, Estela.

CPSIA information can be obtained
at www.ICGtesting.com
Printed in the USA
FSOW02n1043200117
29868FS